DON'T TAKE MY PICTURE!

™

How to take **fantastic photos** of family and friends (and have *fun!*)

Copyright 1989 by Craig Alesse
All rights reserved
Published by Amherst Media
418 Homecrest Dr.
Amherst, NY 14226
Printed and bound in the United States of America
Library of Congress Catalog Card Number: 88-83674
ISBN 0-936262-01-X

Acknowledgements

Thank you to all the people who appear in this book! Your support, enthusiasm and wonderful smiles are greatly appreciated.

Special thank you to the following for proofreading, guidance, and non-stop encouragement: my parents, Tom and Betty Alesse, Mary Jo Muse, Matt Alesse, Bruce Alesse, Beth Alesse and Cindy Small.

Thank you to Barry Evans and Steve Mangione for your expert photographic guidance.

Extra special thanks to the following for appearing and patiently posing in the photographs: Cindy Small, Shaun Smith, Bruce and April Bidwell, John Walgate, Doug Fabian, Leslie Lannan, Ben Fabian, Emma Fabian, Mary Aley, Julio and Sue-z Rios, Mary Gillette, Don Cockerill, Alex Gillette-Cockerill, Kary Gillette-Cockerill, Kisha Hayes, Don and Kathy Miles, Leslie Johnson, John Loder and family and friends, William Aley, Beth Alesse, Dave Bogumil, Elizabeth Bugumil, Amanda Egner, Abby Unger, Bonnie Unger, Mary Jo Muse, Emily Persico, Liz and Pierce Kamke and family, Tony Bonanducci, Bruce Alesse, Debbie Heisler, Ray Rocco, Gil and Marie Laehy, Peter Sheremeta, Dan Alesse, Tom Pallas, Sarah Shechner and Oreo, Mark Kostrzewski, Claire Kostrzewski, Siobhan Nehin, Balwant Karr Kalsa, Hari Krishna Kalsa, Ammet Kalsa and Betty Alesse. Thank you to all the other wonderful faces that appear in this book!

Thank you to Dan Alesse, Mary Jo Muse, Tom Alesse, and Shaun Smith for providing excellent photographs.

Finally, an extra special thanks for the expert editing (and encouragement) of Deborah Cannarella and the excellent graphic design by Mary Aley. Thank you!

Table of Contents

Introduction

Since the beginning of photography, people have been the photographer's favorite subject. It's important to preserve in pictures the faces that are special to us—and to record memorable scenes and events.

Our life is made up of what we do, our friends and family. The photographs we take capture and record our life and its celebrations.

Our photographs are our most treasured possessions—a visual record of our life and the people around us, filled with memories, once-in-a-lifetime occasions and events that are not repeatable. They also help us remember the not-so-special times, which sometimes produce the most unforgettable photos.

Capture your life &
have fun too!

Taking photos of our family and friends is fun, and it's fun to open up your photo album and show them around. One of the most treasured gifts you can give someone is a photo of them with their family or friends. It lets them relive the enjoyment they had.

Affordable cameras now come with auto-focus, auto-exposure, built-in flash and other easy-to-use features. You only need to know how to load and unload your camera—and how to point and shoot. However, to take good-quality photos requires more skill and knowledge than just pointing and shooting.

That's what this book is about—how to take fantastic people photographs! In fact, with the help of this book, you can dramatically improve your people photographs. Plus you'll find lots of new ideas for adding more fun to your picture-taking.

Don't take my picture!

If you take pictures of people, you've undoubtedly heard this phrase before. Many people are shy about being photographed. To get an unwilling subject to pose and be photographed is a challenge for any photographer. In this book, you'll find important tips on how to photograph reluctant subjects.

Timid photographers rarely take good photos!

We all have different personalities. However, to successfully take good people pictures, you'll need to be assertive—even aggressive. Standing in public with a camera asking people to pose for you will require being the center of attention at times—and that's part of taking pictures. If you tend to be shy or timid, give yourself a push to be more aggressive when taking photos of people. Don't be afraid to ask people to pose for you. When you do, try to be pleasant and tactful. Always thank people for being cooperative. You'll find that your pictures will improve and you'll have more fun too!

Cameras

You can take good photos of your family and friends with any kind of camera if you know what you're doing. Some cameras are easier to use than others and have features that make it possible to take photos in a variety of lighting conditions.

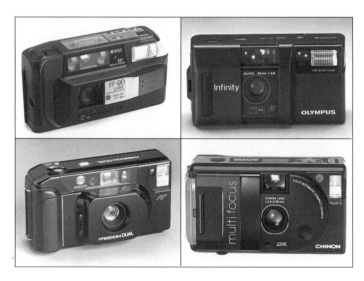

lens-shutter cameras

Most 35mm cameras are available as a lens-shutter or as a single lens reflex (slr). Both types use film that is 35mm wide and comes in cassettes.

Choose your weapon...

• **Lens-shutter cameras** are sometimes called point-and-shoot cameras, compact 35mm, or rangefinder. Most lens-shutter cameras are automatic with auto-focus and automatic film exposure. The latest models come with dual lenses (wide angle and telephoto) or zoom lenses. Compact, quick and easy to use, they are ideal for taking people photographs. You can carry your camera wherever you go—and taking pictures will become spontaneous fun!

SLR cameras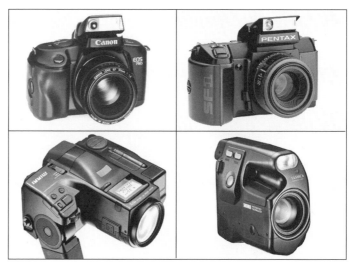

• **SLR or single-lens-reflex cameras** are unique in that you see through the actual lens that takes the picture. This feature allows you to add other lenses, such as telephoto, wide angle, zoom, and macro lenses, and to see through them. SLR's are usually more expensive than lens-shutter cameras. Most SLR's have more exposure controls and advanced features than point-and-shoot cameras. The latest models have auto-focusing and auto-exposure.

• **Polaroid, disc** and **pocket 110 cameras**
We are all familiar with Polaroid cameras. They instantly process prints after you take the picture. Instant results—great for parties!

Disc cameras and pocket 110 cameras are low-cost alternatives to the 35mm camera. They are compact, have a smaller negative and are focus-free.

11

Technical Stuff

Your camera

The shutter: The shutter is the part of the camera that opens to allow light to come through the lens and expose the image onto the film. Many cameras have adjustable shutter speeds—some are automatic and others manual. The average shutter speed is about 1/125 second.

The aperture: The aperture is the opening in a camera lens that controls the amount of light that passes through and exposes the film. Most cameras have adjustable aperture sizes—some are automatic and others manual. The size is dependent on the film type, lighting conditions and shutter speed.

Most lens-shutter 35mm cameras have an aperture and shutter that function as one device (which is mounted in the camera's lens). When released, the shutter also acts as the aperture.

But only what you absolutely need to know!

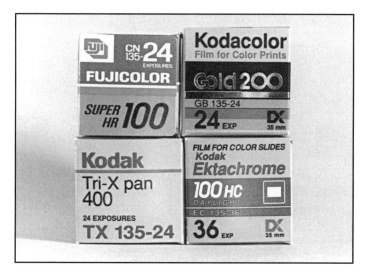

Film

Most pictures are taken in color, although many photographers prefer black-and-white film. Color film is available as print film or slide film. Print film produces prints only. Slide film produces slides, although prints can be made from the slide later.

Each type of film is designed to perform best under under certain lighting conditions. This is called its sensitivity and it is rated by an ISO/ASA number. The greater the number, the more sensitive the film is to light. A highly sensitive film (with a ISO/ASA of 400, for example) allows you to take photos in low light (such as inside without a flash) because less light is required to expose the image to the film. However, as a general rule, the lower sensitivity of the film (the lower the ISO/ASA), the better the picture quality.

When loading many cameras, you need to set the film's ISO/ASA number. This sets the exposure system in the camera to the correct setting for that film. Most new 35mm cameras have a DX coding feature, which means the camera reads the bar code on the film cassette and automatically sets the proper ISO/ASA number.

A few extra comments about film in your camera:

• **Rewind the film!** The biggest mistake people make when using their 35mm cameras is forgetting to rewind the film cassette at the end of the roll—before they open the camera's back. They expose the film to light and it's ruined.

• **Process your film as soon as possible after taking photos.** This will insure the best image quality. Keep the film in its plastic cannister after use to protect it from dust, which could scratch the film during processing.

• **Store film in a cool, dry area**. Avoid the glove compartment or bright sun.

Lenses

The angle of view of a lens (what the lens sees) is indicated in millimeters. The lens that comes with most SLR cameras is 50 millimeters. Its angle of view is about the same as that of the human eye.

A **wide-angle lens** sees a wider angle of view than a normal lens. It can see things we normally see only by moving our heads. These lenses are quite useful when taking photos inside—particularly group shots.

Wide-angle lenses are less than 50 millimeters. Most lens-shutter cameras come with a lens that is about 35 millimeters, which is fine for

most photographs. However, it can produce a slightly distorted image if you take photos up too close.

Telephoto lenses bring you closer to your subject without having to be too physically near your subject—like a telescope. Telephoto lenses are lenses that are more than 50 millimeters. Telephotos are great for wildlife and sports photos. They are especially good for portraits because they don't distort facial features the way a wide-angle lens can.

Many lens-shutter cameras have a lens that is adjustable to a telephoto or wide-angle setting. Some have a zoom lens, which allows you a variety of settings from wide angle to telephoto.

Flashes

Many 35mm cameras have a built-in flash. A flash is invaluable when taking photos of people inside or at night, when the available light is too low. Most of the new flash units are automatic and provide the exact amount of light that is needed. Flash units also can be used to fill in light when taking photos outside in shaded areas, or when using backlighting (see p. 40-41).

When taking flash photos, keep in mind the range of the flash. Most camera flashes will not illuminate a subject more than 10 to 15 ft. away. Refer to the camera manual to find what this distance is. Any photos taken beyond this distance will not be illuminated by the flash and are a waste of film.

When taking flash pictures, be aware of reflections from the background. If a window, glass or other reflective element is in the background, change backgrounds or reposition yourself. If the problem background is at an angle to the camera, you won't get strong flash reflections.

Many flashes will produce an unappealing background shadow. You can minimize this if you move your subject away from the background so the shadow will not be as strong.

Chapter 4

How to Point & Shoot Your Camera

It's important to hold your camera steady and aim it accurately if you're going to take good photos. The correct stance will help you produce pictures that are clear and sharp, with good composition.

And get sharp pictures!

Follow these simple steps:

A. Hold your camera steady in a comfortable position with both hands. Stand with both feet firmly on the ground. Your index finger should easily reach the shutter button.

B. Look into the viewfinder and close your non-viewing eye. Bring your elbows in close to your body to minimize camera movement.

C. When you are ready to take the shot, exhale slightly, then momentarily stop breathing (so you're not moving)...

D. At that moment, **SQUEEZE** the shutter button, don't push it—or you will move the camera during the exposure and blur your picture. Try to always use the tip of your finger when pushing the shutter button. This way you will push only the button and not the camera body.

Practice holding and using your camera so that taking clear pictures comes naturally.

If you're feeling shaky...

If you feel like you're not holding the camera steady enough, try leaning again a stationary object, like a door frame or tree. This will help you brace yourself and stabilize the camera when you take a picture.

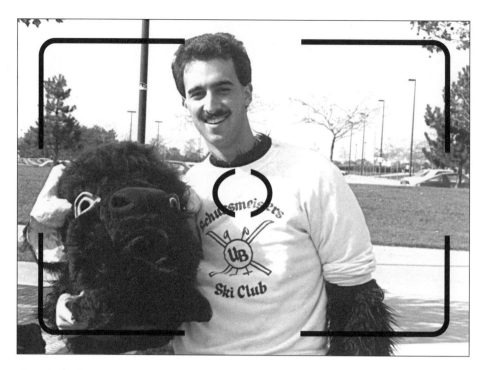

Auto-focus cameras

Lens-shutter cameras come with either focus-free or with auto-focus lenses. Focus-free lenses have a fixed-focus lens, which means everything will be in focus from several feet to infinity. Auto-focus lenses have a focusing mechanism in the camera. They will produce photos that are clearer and better focused than a focus-free camera.

On most auto-focus cameras, there is a small area indicated in the center of the viewfinder (this is usually a circle or bracket). Make sure this area is positioned on your subject. This is the area the camera will adjust its focus to. If the focus spot is positioned on a distant background or on an object in the foreground, these areas will be in focus—not your subject.

Most auto-focus cameras have a pre-focus feature. To use this feature, look through your viewfinder and place the focus spot on your subject. Hold the pre-focus button (usually the shutter button held halfway down) to lock the focus on this spot—then re-compose your photo and take the shot.

If you're photographing two people, be sure the focus spot is not on the background, or you'll create a photo with two blurry people and a background in perfect focus. Pre-focus by placing the focus point on one person and locking it. Then re-compose the shot for two people.

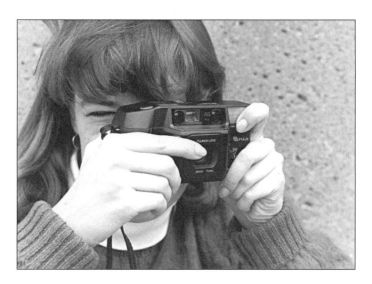

Don't block the lens or flash!

Make sure the lens cap is removed and not in the way. Also, check to be sure the camera strap is not in front of the lens. When you grasp the camera, position your fingers so they are not in front of the camera's lens or the flash.

Composition

Here are some techniques that will consistently produce good, well-composed people photographs.

too far

There are no rules—but here are a few anyway.

Get up close!

The best people pictures are those taken up close because they show faces and expressions. Faces show emotions and tell us about our subjects. A facial expression is how we read how people feel, and how we best remember them.

Photos taken from too far away don't have impact and are usually disappointing. As a general rule of thumb—get up close to your subject.

Note: Refer to your camera manual to see how close you can get with your camera. Most lens-shutter cameras allow you to get within 3 1/2 ft.

The eyes have it.

Eyes show a person's character. Eye contact is how we connect with people. This is also true when looking at a photograph. Have your subject look directly into the camera and you'll see the dramatic effect it can have on your photographs.

If you're having your subject pose for the camera, try several shots—one with the subject looking into the camera lens making direct eye contact; one with the subject looking to the side without making eye contact (ask your subject to look at a specific object when looking away from the camera so the eyes appear focused). Select the best shot after they're processed. Both can be successful.

Telephoto or zoom to get up really close.

A telephoto or zoom lens allows you to get close to your subject without actually being physically close. With a telephoto, it's especially important to hold the camera very steady or use a tripod. Camera movement with a telephoto will give you a blurry photo.

Select simple backgrounds.

Keep the area behind your subject as free of
visual clutter as possible. Your subjects will get
lost in a cluttered background—this makes the
photo confusing.

Watch for objects in the background...

just right

Watch out for objects in the background, such as a tree or telephone pole, that might look like they are coming out of people's heads. Check the image through the viewfinder and, if there's a problem, ask your subject to move slightly or move the camera to one side or the other.

If the available background has clutter, try shooting down or up on your subject. This will make the ground or sky your background.

Vertical or...

...horizontal?

Because of their rectangular frames, 35mm cameras allow you to take a horizontal or vertical photograph. The camera is designed to encourage horizontal photos, which are good for group shots and most photos of people. However, many times a vertical composition is better because it shows the entire person's body and cuts out much of the background. You may want to shoot both a horizontal and vertical shot and select the best one later.

Frame your subject.

You frame photos by how you position your subject within the camera's viewfinder. The subject may be centered or off center. Many people, when taking a horizontal portrait of one person, will center the person in the frame. Sometimes this can produce a strong portrait. Other times, however, framing at center can produce a boring picture.

One way to improve on a centered picture is to place the subject to the side of the frame. This can add interest, especially if the background is a simple one.

When photographing a profile or a slight profile, it helps to have the framing off center. Leave more space in the direction your subject is facing. This adds more balance to the photograph.

Note: When taking an off-center portrait with an auto-focus camera, pre-focus on the subject.

too much space

just right

Head space

Many beginners compose photos with too much space above people's heads. Lower or tilt the camera and show more of the person and less of the background. Keep the space above your subject's head to a minimum.

Don't take all your photos at eye level.

Taking all your photos from a standing position can make for boring and uninteresting people photos. Take your photos from different angles to add visual interest and power, and to create a mood.

Shooting down makes your subject appear small and insignificant. This can be an interesting composition, especially if the subject is tall. However, shooting down can be a problem when shooting little kids. All your pictures will have them looking up at the camera—making them look smaller than they are. Take some of your kids photos from their eye level—it will help you see the world from their perspective.

Shooting up can make people look bigger and more impressive. It can also create an strong portrait. Shooting up can, however, sometimes distort faces, especially when the subjects are looking down into the camera. This angle can also produce unflattering double chins.

Shooting at eye level is a neutral position, but it is appropriate for many photos.

add visual interest & power...

shooting down (above)

neutral position (below)

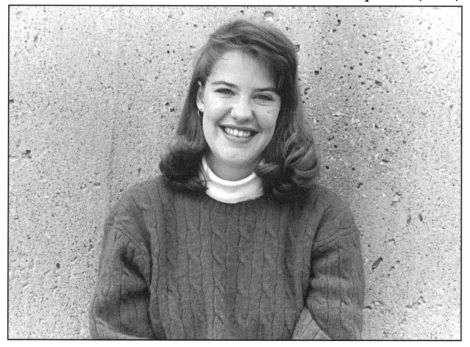

Crop your photos.

Cropping your photo means deciding what to include in the shot and what not. When you look into the camera's viewfinder, carefully consider what you want in the photo and what does not belong. Check the edges of the frame. Do you have a tree or telephone pole "growing" from your subject's head? Are you cutting tops of heads off or cutting legs and feet off where that may look unusual? Check that the horizon is level and that people appear to be standing straight. (In other words, hold the camera straight.)

Include only what is important to your photo-graph and crop out the rest. Careful cropping will dramatically improve your photos.

Include only what is important...

More easy ways to create interesting compositions!

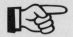

Use a frame.

A simple way to make people photos more interesting is to frame your subject in a door-way or similar setting. Tree branches and arches make good frames. Frames can build, emphasize and strengthen your photos by adding visual interest.

Note: If you have an auto-focus camera, make sure to pre-focus on your subject and not on the frame.

Use more foreground space.

Sometimes extra foreground in your portraits will add interest. Try including an object in the foreground to create a sense of scale. If you're using an auto-focus camera, pre-focus on the subject before you take the shot.

Play with line, shape and patterns.

If you're clever, visual elements like a fence, porch or sidewalk can strengthen your pictures and make them more creative and interesting. These elements can be used to show a sense of depth. Lines can also add meaning to a photo or add personality by showing dominance, strength or power. A photo with balanced visual elements in patterns can show serenity and peace. Angles in a portrait can create action or imbalance.

Go for simplicity.

Simple compositions are the strongest and most successful. These are photos taken with simple backgrounds and up close to your subject.

Light

Photographs are created by light reflected from your subject. The quality of light is important to get good people photos. Become aware of light—it will help you take more successful and more interesting photos. Here are some basics on good photographic lighting.

direct sunlight

Available/natural light

Available-light photos are taken with naturally appearing light produced by the sun or room lights. It can be direct or diffused.

Direct sunlight rarely produces flattering people photos. The light is harsh and creates strong highlights or shadows on faces. Bright sun also forces people to squint, creating more facial lines and a distorted expression.

The stuff that great people pictures are made of!

Diffused light

Diffused light appears in shaded areas or under overcast skies. It is much more flattering for photographs of people because it produces soft shadows and minimizes facial blemishes. Because diffused light is not as strong and harsh as direct light, your subject will have a more relaxed and natural facial expression.

Avoid fluorescent light.

Fluorescent-light fixtures produce light from above and create facial shadows with unflattering green or bluish colors. If fluorescents are in the room, use your flash.

Flash

A flash is helpful because it allows you to take photos inside in low light. You can take photos anywhere and with any type of film. However, there are trade-offs when using a flash—they can produce unflattering portraits with strong shadows and highlights with washed-out detail.

Check the camera manual to find the flash range of your camera (the distance the light will travel). The flash range will vary with the film you use. Flash pictures taken beyond the flash range will be underexposed and too dark.

A flash can also produce "red eyes"—those red dots that you often see in the center of people's eyes on color prints. This happens when direct light from a flash reflects on the blood vessels in the subject's eyes.

You can take photos anywhere...

You can prevent this problem by having people turn their heads to one side slightly or by mounting your flash to one side of your camera. (This is not possible with many cameras with built-in flashes.) Many of the new point-and-shoot cameras have a flash that extends slightly above the camera, which minimizes the "red-eye" problem.

Backlight

Backlight is direct light that strikes your subject from behind or slightly behind. This produces a flattering photo with bright highlights around the subject's hair, setting the person apart from the background.

However, the camera can misinterpret this bright light and adjust the exposure to the light instead of to the subject. Your subject will be underexposed and appear as a silhouette against a bright background. If your camera has a backlight-exposure switch, turn it on. This will compensate for the backlighting and produce a photo correctly exposed for the subject.

Fill-in flash

Another solution to backlighting problems is to use a fill-in flash. Many times there is enough light to take a photo, however, the light source is above or behind your subject and casts the face in a shadow. In this case, with your point-and-shoot camera, use the camera's flash. The flash will fill in the shadows and produce a flattering well-lit picture, whether inside or outside.

The color of light

The time of the day at which outdoor pictures are taken will affect the color of the light and the colors in the photographs. Mid-day sun will produce the most natural colors. Early morning and late afternoon sun will produce a warm, reddish-yellow glow in your photos.

Catching the Moment

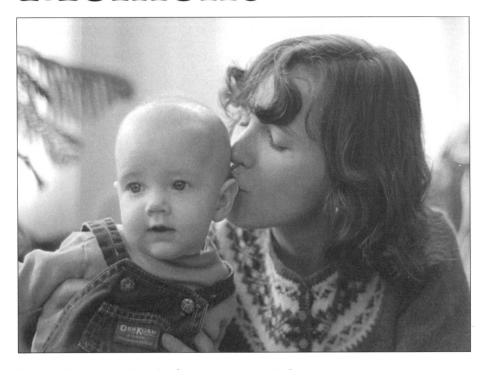

No matter what kind of pictures you take, "catching the moment" is critical to getting a great shot.

What is "the moment"? A camera captures only a moment in time—a fraction of a second. The "moment" you photograph should be the ideal expression of an emotion or action—the most significant or telling point in time. A photo at the wrong time can be mediocre and boring. A photo at the right time can be exciting, dramatic and memorable.

A smile or expression is a changing thing. When we see it in reality, we see the whole thing. The camera can capture only one moment of it. Your goal in people photography is to catch the best moments.

How to get a great shot!

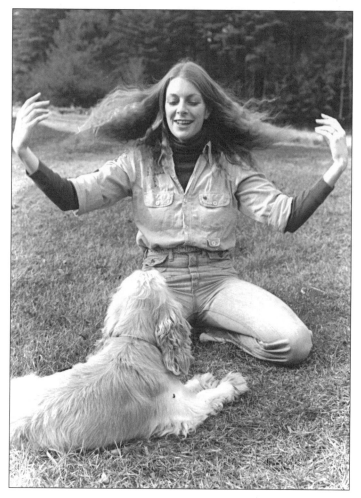

Here are several things to remember when trying to catch the moment.

Timing

Timing is important—catching facial expressions, body positions, personal interactions. They happen quickly—keep an attentive eye and quick reflexes. See the moment before you catch it. Anticipate, wait patiently and be prepared. Have your camera ready. Snapping a second too soon or too late can make the difference between a boring shot and a prizewinner.

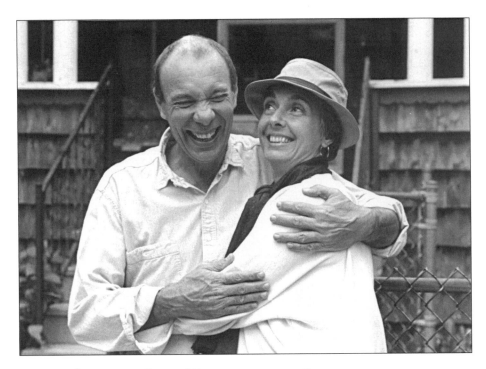

Practice seeing the moment.

Watch people—when you become more aware of
people and their characteristics, you will take
better pictures of them. Study how they talk,
gesture and move. Notice subtle facial move-
ments, smiles, body language, and gestures.
What moments are the most interesting, the
most active? Your camera will capture only
that one fleeting moment.

The face grabs our interest.

Look for an expression, an emotion, a sparkle
in the eyes. Watch the face to wait for the best
moment to happen.

Take more than one...

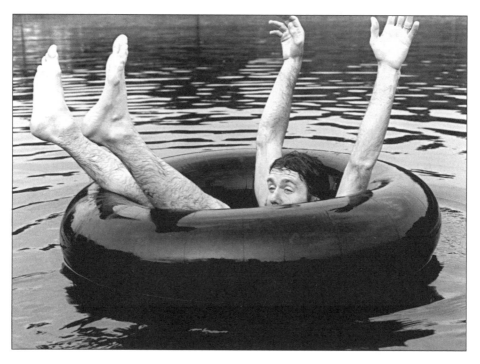

Be ready!

Always have your finger on the shutter button and poised to squeeze at the right time! If you wait a second too long, you'll miss it.

Take lots of pictures.

Sometimes no matter how skillful you are, you won't be able to catch the moment the first time. Take several shots. One of them will capture the moment you want to keep.

Candid & Formal Photographs

There are basically two types of people photographs: candids and formal photographs. Candids are informal shots, taken when the subject is not posing for the camera. Formal photographs are when the subject is posing for the camera. Most of us take both types, depending on the occasion.

Putting people at ease...

The best candid photos are of people completely engrossed in doing something. Catch your subject at work or give them an activity to take their mind off you and the camera. Try to catch a spontaneous pose—"catching the moment" will be a key to success. You'll need to be patient waiting for that moment, but then you'll need to be quick with the shutter when the moment occurs.

Formal photos are often stiff and uninteresting, with no life or spontaneity. When your subject is too aware of the camera, and self-conscious posing for it, the pictures can look unnatural.

If you are taking a formal photograph, catching the moment will require interaction with your subject.

To get your subjects into interesting poses, you need to help them relax. The best way is to create a relaxed atmosphere. Many photographers play music. Engage in conversation to help your subject relax and become less aware of the camera. Try not to rush. Ask questions (not the yes or no variety). Build rapport. When your subject is relaxed, you'll get better, more natural-looking photographs.

Sometimes a prop will not only help relax your subject, but also make the photo more interesting. Select something the person is comfortable with, such as a book, musical instrument, or favorite hat.

Posing

Turn your subject slightly to one side at an angle to the camera. Try not to have them facing the camera directly unless that is the effect you want. Be aware of subtle body language. Have your subjects slowly turn their heads so you can see the best positioning and angle. If you notice a double chin, ask your subject to raise the head slightly or you should raise the camera.

People sometimes feel awkward positioning their hands and arms. If this is a concern, demonstrate the position you want or give them a prop to hold. Try posing them where they can position their hands on a table or chair. The goal is to have them appear relaxed and natural.

Facial expression

The face tells all. If your subject is relaxed, it will show in the face. Facial muscles should be relaxed and not tense; eyes should be smiling, relaxed or revealing. Ask your subjects to relax and smile with their eyes as well as their mouths.

Clothing

Clothes are important to most people. Try to photograph people in clothes they like—they'll like the pictures too. When posing, check to make sure the clothing is positioned properly: buttons are buttoned and collars are straight. Also, check that your subject's hair looks okay. A quick brushing can make your shot look much better.

Smiling too much

It's great to have your subject smile, however, it is possible to smile too much! An exaggerated smile can make your subject look rather foolish and distort the face. So ask them to smile—but not too much. The best way to get a natural smile is to converse with your subjects about things they enjoy or even crack a joke. This will produce a genuine smile.

A few pointers to make everyone look good

When taking pictures of people, you will frequently need to contend with unique characteristics or situations. Here are a few pointers to help you out:

1. Eyeglasses: Glasses can conceal a person's face. Frames can cut across eyes or make eyes appear dark. They can also produce reflections, especially when you're using a flash. Many times these problems can be solved just by asking your subject to turn the head or tilt the head down slightly until the reflections disappear. If glasses still are a problem, take several shots—some with eyeglasses on and some with your subject holding the eyeglasses as a prop. You can select the best shots later.

2. Wrinkles: Facial wrinkles can produce interesting photos with a lot of character. If you want to minimize wrinkles, however, use diffused light from a window or shoot in a shady spot. Direct sunlight or a flash can emphasize wrinkles by making strong shadows. Some photographers place a diffusion material, like cellophane or nylon stockings, over the camera lens to minimize wrinkles and facial blemishes. You can also buy diffusion filters.

3. Prominent nose: If you want your subject's nose to appear smaller, have the subject face the camera and keep the face level. Avoid profiles.

4. Weak chin: Add prominence to the chin by lowering the camera slightly and shooting up on your subject.

5. Double chins: Shoot from eye level, have the camera slightly higher than eye level or have your subject raise the head slightly.

6. Hair: If hair is a strong feature of your subject, backlight to emphasize hair highlights. Position your subject where strong light is slightly behind or above. Use the backlight-exposure setting on your camera or use a fill-in flash.

Snapping Group Shots

Whether photographing a large or small group, taking a successful group photo is a special challenge—you are capturing many faces, not just one. It's also more difficult to "catch the moment" in which everyone has the right facial expression and pose. Groups of people can be intimidating to a photographer—but this should not discourage you.

My eyes were closed!

Get their attention.

When photographing a group, you're capturing many personalities. Some will be impatient, so you need to get the shot you want and yet work as quickly as you can. Talk with the group to get their attention as you work. Establish a continuing dialogue and make comments to individuals to generate interest. Perhaps tell a quick joke to get a response or use one of your best one-liners. The goal is to catch their attention, gain cooperation and take the best photo you can.

Arranging the group

Move people close together. If the group is large, position tall people in back and short ones in front. Position people facing slightly to the center of the frame to create a sense of balance and togetherness. Make sure people don't block one another—you want to see everyone's face clearly. Try to select a simple background with a minimum of visual clutter.

You might try something that draws them together visually, such as a prop.

Enjoy taking the picture and stay relaxed and confident. If the subjects sense your relaxed attitude, they will relax and that feeling will come across in the photograph.

"My eyes were closed!" The larger the group, the greater the chance of catching someone with their eyes closed or with a poor expression. Again, take several photos, not just one.

When you are ready to take the shot, ask for attention and a smile. Ask everyone to look at you and the camera. Take several photos until you have caught one good one (talk during the entire process to keep their attention). Make it fun. Capture the spirit of the group—and work fast!

Ask for attention & a smile...

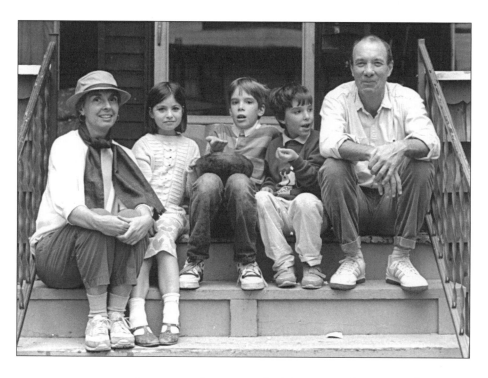

An annual group shot is a great way to document family and friend get-togethers. Whenever you have an annual event, get as many people as you can in the group shot. It's the kind of picture everyone in the group will want a copy of.

A trick!

One "trick" to catching a spontaneous pose is to quickly take a photo just before the group is ready. Or quickly take a second shot just after they've heard the shutter click from the first shot. Usually at this moment, they have relaxed slightly and won't be expecting another shot so soon. This will catch a more natural expression. (Make sure your flash has fully recharged for the second shot—refer to your manual to find how many seconds it takes.)

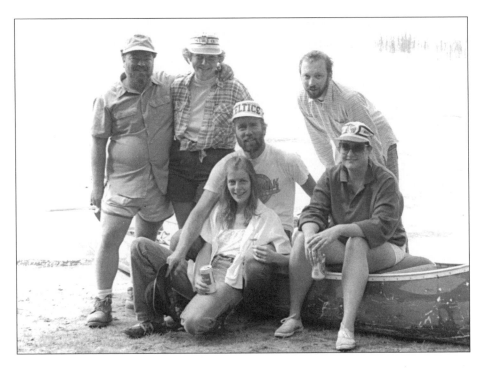

Getting yourself in the shot

If you're photographing a group event that you are part of, you may want to get into the shot. The best solution is to use a camera with a self-timer. Set up your camera on a tripod (or an improvised support like a table) and compose the shot. Then set the self-timer, release the shutter and dash into your position. (You should have about 10 seconds.) It's wise to know where you'll be posing in the shot before you start the timer. Some camera models have a remote control shutter. Take your position, smile, and release the shutter with the remote control.

Another way to get into the shot is the "your turn, my turn" technique. Take the group shot you want. Then arrange the setup and ask a willing group member or honest passerby to take a shot of you with the group.

Group Photo Tips

1. Work as quickly as you can.

2. Get the group's attention.

3. Position the group together and facing slightly to the center of the frame. Make sure you can see everyone's face.

4. Stay confident and relaxed.

5. Take several photos, not just one.

6. When you're ready to shoot, ask for attention and a smile.

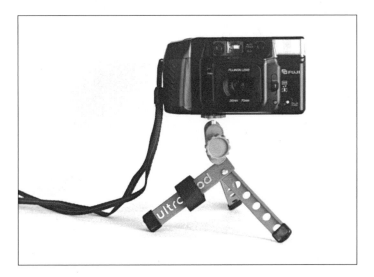

Tripods and mini-tripods

Tripods hold the camera perfectly still, helping you to produce a sharp image.

Mini-tripods are designed to support your camera by resting on an object, like a table or car top. Some models have velcro straps so that they can be attached to tree branches or a chair. Mini-tripods are compact, lightweight and can be carried on your camera strap or in a camera bag. They're ideal for group shots and self-portraits.

Dealing with muggers

One of the greatest challenges when taking pictures is keeping people from mugging for the camera. This is especially a problem with kids and some silly adults. (I was a master mugger when I was a kid, and I still mug when inspired.) Having a few "mug shots" can be fun, but sometimes it can be frustrating, especially in group shots. Here are several strategies for dealing with muggers:

• Take a few photos to relax them. They might get tired of the mugging.

• Wait until they're finished or until their face hurts.

• Aim your camera without looking through the viewfinder and act like you're not taking a picture. Then squeeze the shutter when they're not expecting it. (This is a tough problem. You have to be sneaky.)

• Take many photos. This can be expensive, but it will increase your chances of getting one shot without a foolish expression—this is the picture you keep.

• Remember the old quick-second-picture-trick (like the one you use on difficult groups)? Take a picture of the mugger and then a quick second shot. After hearing the shutter go off the first time, the mugger will stop, thinking the shot has been fired. The second shot is the one you want. You catch them off guard and hopefully not mugging. We must be sneakier than they are. (Good luck!)

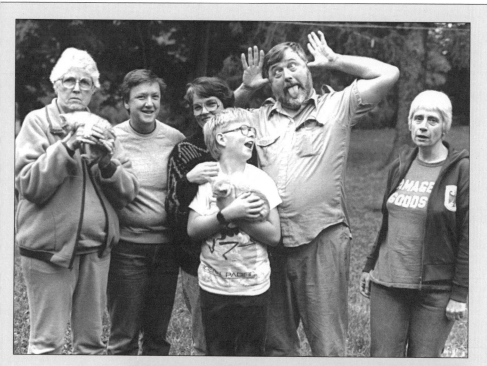

Bunny fingers

People who make "bunny fingers" behind other people's heads are the toughest photographic subjects. Not only do they look silly, but they're making someone else look silly too. Try the same strategies as when dealing with muggers. If none of these works, ask this person to go home.

Photos of Celebrations & Special Times

And some that you can create...

Birthdays

A camera should always be around at a birth-day celebration—especially one with kids. Taking birthday pictures is a great way to record a kid's growing up. Some picture ideas include: blowing out the candles, unwrapping presents, group shots, cutting and eating cake.

A flash can be helpful when these shots are indoor, however, consider using a extra-light-sensitive "fast" film to take photos without flash. This speed of film is ideal for photos lit by candlelight and other available room light.

Weddings

A wedding enables you to photograph a full range of human emotion and action. Your goal is not to duplicate the photos of a professional, but to get spontaneous shots a professional would miss. (Turn down invitations to be the offical photographer—leave that to a pro.)

The event is not repeatable, so plan to have fresh batteries and plenty of film so you don't miss anything. Think through beforehand what you want to cover so you can anticipate where you need to be. You may want to cover preparations, the ceremony, leaving the church and the reception.

A telephoto or zoom lens will be helpful in getting shots up close. Make sure you get plenty of candids and formal shots of not only the couple and family, but everyone there. Photograph the faces, emotions and fun.

Parties

Parties are one of the best times to take photos and capture a group's fun. Or if they're not having fun, take a few photographs to spice things up and help people smile and become more animated.

Take plenty of action shots—people eating, playing games, enjoying themselves. Your goal should be to catch the moment of spontaneous fun. Make extra prints to pass out at the next party.

Humor

Most people have a sense of humor, so it's natural that this can make your photos more interesting.

Develop an eye for it. Looking for humorous situations requires being aware and looking for these types of photographs. Timing is critical when catching humor in pictures. So you should always have your camera handy and be ready to "catch the moment."

Some occasions are more potentially humorous than others—for example, parties or photographing kids and pets. Be on the lookout for humorous opportunities.

Have fun yourself when taking pictures—this will help bring humor out in people. Making a funny remark or joke can bring a natural smile to faces.

Vacation and travel photos

A vacation is an experience we look forward to all year, so it's important to capture the events and the feelings in pictures. In fact, your pictures are the ideal souvenir. Let your photos tell the story of your vacation.

Take pictures of people doing things—riding the roller coaster, camping or lying on the beach. Try to have your friends and family in each shot—even scenic shots. This will make the pictures more memorable years from now. Get a shot of each place you visit and all the important things you do. When you get your pictures back you can relive the fun again.

The ideal souvenir...

These are once-in-a-lifetime photos and you don't want to miss getting them. So make sure you know how your camera works before you leave for your trip. Be sure you have fresh batteries in your camera and plenty of film. Shoot plenty of film so you have a complete record of all the fun.

If you're traveling by plane, avoid having your film X-rayed at the airport security check. Carry your film in hand so it can be inspected separately. Place it in clear plastic bags so it can be easily seen by inspectors. If you want to pack your film in luggage, place it in special lead-lined bags that are available at your camera store.

Be sure to get your photos processed as soon as possible. This will ensure the best-quality images.

Baby photos

A new baby's arrival is filled with emotion—an ideal time to photograph and document the early expressions of life. You will also need pictures to pass around and send off to friends and family.

There is a story to tell, so let pictures capture it in sequence. Take photographs in the hospital, coming home, and during the important first months of life.

Take plenty of close-ups of the newborn with mother, father, grandparents, brothers and sisters.

Rather than using flash, consider using fast, extra-sensitive film that allows you to photograph in low room light. This will give your pictures soft, natural-looking lighting.

Some picture ideas might include: first photo of mother and baby (or father and baby), baby sleeping, the bath, first steps, baby and grandma, playing with new toys, a dress-up portrait. Keep your camera handy and be ready to catch spontaneous shots too.

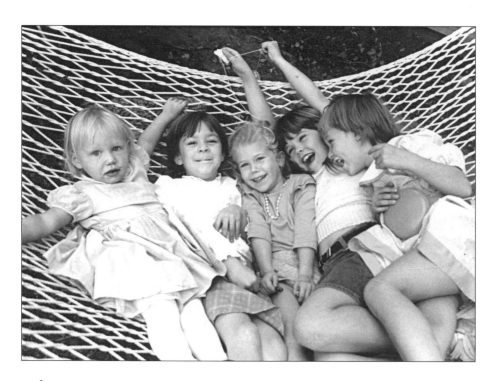

Kids photos

Young children are fun to photograph because they are uninhibited, spontaneous, full of action and emotion. It's rewarding to document a child's growing up and learning. Here are several things to remember when photographing children.

• **Be patient.** Capturing "the moment" requires some waiting. To get prize shots you must be alert—kids are fast! Follow their actions through the viewfinder and have your finger on the shutter ready to snap a shot.

Uninhibited & spontaneous...

• **Capture personality.** It may help to get kids busy with a toy or friend. This will produce more expressions and photo opportunities and get their attention off you and the camera. Photograph when they're doing something. It will be more fun and will tell a story years later.

Some kids are shy about being photographed. A toy or prop will be helpful in putting them at ease. Instead of asking them to smile, ask them what they like to do. While they tell you, they'll smile naturally without being self-conscious.

• **Don't shoot all your photos from one angle or position,** especially from the standing position. All your photos will be of the children looking up at you. Lower the camera and photograph at their eye level. This will create an interesting perspective and add more intimacy to your photographs.

• **Shoot your photos fast**. Special moments are fleeting. Shoot extra photos. When photographing any spontaneous event, speed will increase your chances of catching prize expressions and moments.

Special moments are fleeting...

• **Don't push your luck.** Kids will tire of being photographed. Keep your photo session short and productive. Thank them for being helpful.

• **Don't wait for just special events.** Some of the best photos can be taken during not-so-special times. Some photo ideas include: playing in the yard, getting a haircut, going to bed, climbing into the car seat or playing with the family dog.

Note: Kids like to mug for the camera. If this is a problem, see Dealing with muggers, p. 58.

Pets and people

Pets are fun to photograph because they have personalities of their own. Also, they are spontaneous and uninhibited. Here are a few tips for photographing pets.

• As with children, this type of photography requires patience and a bit of luck. You need to be ready and quick to catch the moment. Study the pet's behavior and watch its movements. This will allow you to anticipate the action and get the best angle.

• Don't work too close. Pets move fast and you'll need to follow them around. A telephoto lens might be helpful because it will allow you to get close-ups from a distance. Try to photograph with a neutral-color background so the animal will stand out. Avoid white or black.

• Food can be an easy way to get your pet's attention. Dog treats might be the best way to get your dog's cooperation and the right pose (this sometimes works with people too). A ball also can be an ideal prop to get a dog's attention. Or try throwing a stick, and when the dog returns

The results can be fantastic...

with it, snap a shot of him wagging his tail. Crinkled paper gets a cat's attention and brings out playful behavior.

• A portrait of people and their pets can make interesting pictures. Have the pet owner interact with the pet to get them in an interesting pose.

• Children and pets together can make for an extra-challenging shot. Both move quickly, but the results can be fantastic. You may want to shoot a sequence of shots while they're playing so you're sure not to miss anything spontaneous.

• A flash can be the best way to get indoor photos of your pets. If you're outside, sunny lighting or backlighting can produce dramatic results because it brings out the highlights in the animal's fur.

Sports

Sports photos of friends and family are especially challenging and fun to take. People in action are completely wrapped up in what they're doing and unaware of the camera. When photographing sports action, your goal is to catch the peak of action (the "moment"). Anticipating action requires a good sense of timing. You'll also need to take extra photographs.

Action shots can appear blurred if the shutter setting of your camera is too slow for the speed of the action. If you can adjust the shutter speeds on your camera, select a fast shutter speed to freeze action. Another way to help freeze motion is to shoot the subject head-on so their motion is less apparent.

People in action...

If your camera selects the shutter speed automatically, try panning with the action (that is, moving with the subject) as you take the picture. This will freeze the action and produce an interesting blurred background effect. Also, using the flash will help freeze action.

Anticipate the direction of action and make sure there is enough room in the frame for the action to move into. Otherwise, you may cut off heads and legs and miss the focus of the activity.

A telephoto lens can be invaluable in sports photography. It allows you to take close-ups without being dangerously close to the action.

Showing Off Your Photos

Showing your photos is as much fun as taking them! The goal is to make them handy so you can show your photos and enjoy them any time. Keep them out of the drawer and make your photos part of your living space.

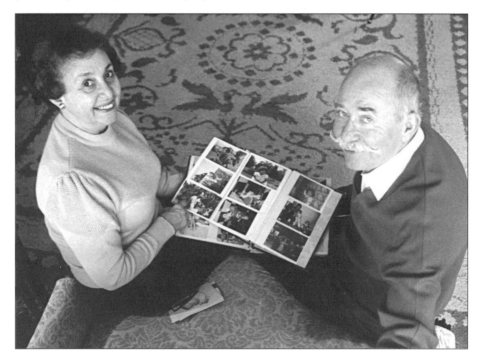

Here are some ideas for showing off your photos:

• **Albums** are the best way to store and show your photo collection. There are two basic types: the plastic-sleeve type where prints slip into plastic envelopes in a 3-ring binder; and the magnetic page type, which is a waxy card

As much fun as taking them!

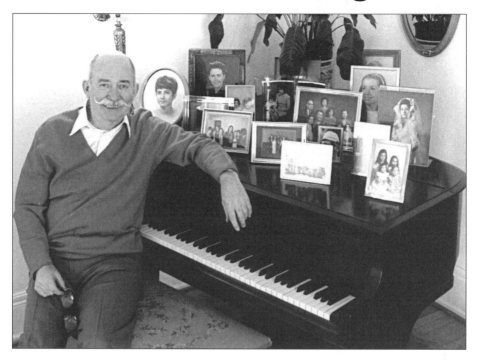

board surface with a plastic page cover. Both do the job. Albums are great for arranging photos in sequence and labeling them with the date and place they were taken.

When arranging your photo album, edit the photos and remove those that are unfocused, blurry or have poor exposure and composition. Also, remove any duplicates. Only show your best shots.

• **Frames** are ideal for displaying your favorite photos. They come in a variety of sizes and shapes. Some hang on the wall and others stand on a desk or tabletop. They come in plastic, metal and wood. Consider having your best shots enlarged for a bigger frame. A framed photo makes an ideal gift!

• **Make extra prints.** Part of the enjoyment of taking pictures is having your family and friends enjoy them too! If people receive copies of pictures, it makes them more willing subjects the next time you're taking pictures. Many processing centers have "double specials" and make extra prints to give to friends and family. Print two and give one away!

Many processing labs will also make large poster prints—a great way to enjoy your best shots!

• **Christmas cards and wallet shots**. Be creative in how you use your photographs! A Christmas card snapshot of your family is an excellent way to share a favorite photo. Wallet shots are a must for parents, grandparents, husbands, wives, girlfriends, boyfriends or best friends.

Refrigerators are for photos...

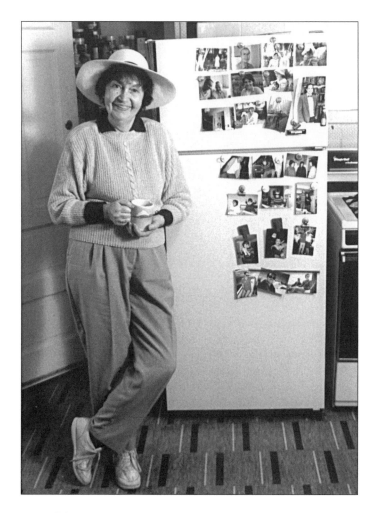

• **Refrigerators**—Everyone knows that the main reason to have a refrigerator is to display your latest photos of friends and family. Keep a good supply of magnets and snapshots on your fridge door.

• **Caption stickers**—Some people like to use caption stickers to add spunk to their photos. You can buy them with printed captions or you can write your own.

Extra Creative Ideas for People Pictures

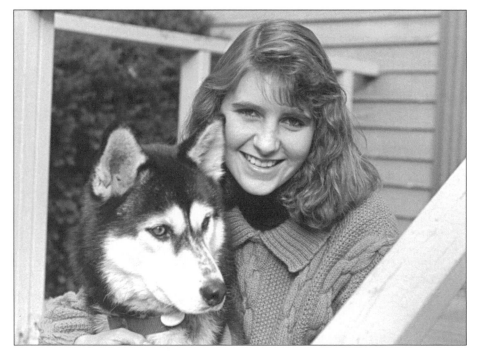

Self-portraits, jump shots, funny hats and more!

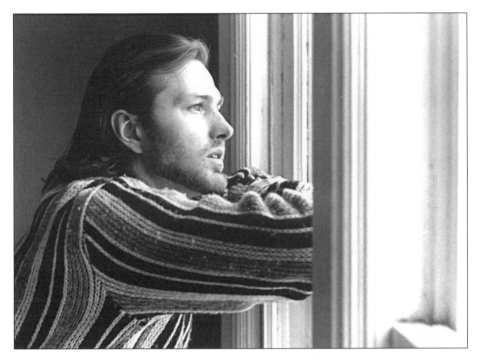

Profiles

A successful profile photograph is difficult to take. It's not a pose that is flattering to everyone. It's usually better to show a person's full face. However, if you take a good profile shot, it can be a real prize.

When posing your subject, carefully select a lighter background to make the facial outline stand out. Position the profile in the frame so there is more space in the direction your subject is facing. This will balance the composition.

Consider a silhouette. Backlight your subject with a little light reflecting from the face—and have the background brightly lit. Turn off the flash.

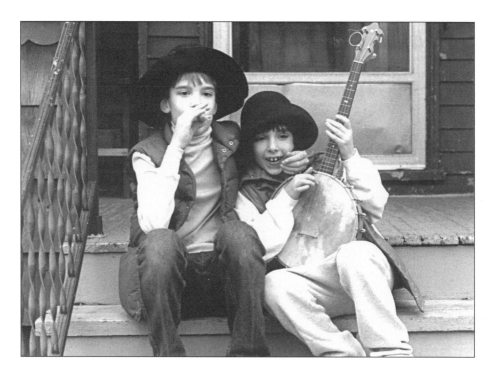

Hats, old tires
& other nifty props

Props are great tools to add visual fun to your photographs. They also can provoke a spontaneous response from your subjects. You're limited only by how imaginative you are. Unique clothes and hats can be extra fun props. Place a funky hat on your model and watch the inhibitions vanish. Look through the closet or flea markets. Props make picture-taking more fun!

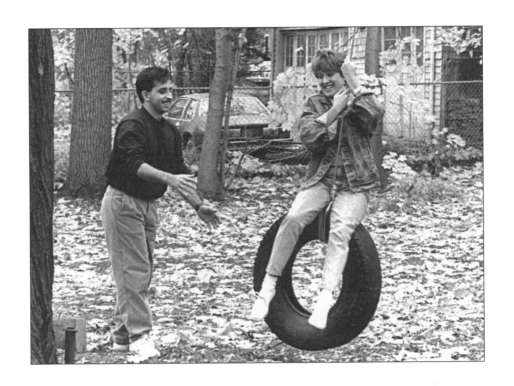

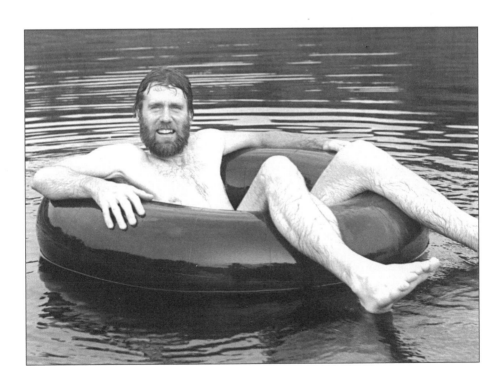

reflective
surface

Self-portraits

It's surprisingly easy to take a picture of your-
self. If fact, some people have an entire photo
album of their self-portraits in various locations
and settings. It's an enjoyable and challenging
photo assignment.

• **Self-timer:** The easiest way to take a self-
portrait is to use the self-timer in your camera.
Most cameras have them; check your camera
manual. Place your camera on a tripod or
similar support. If you don't have a tripod, you
can place your camera on a table, car or other
secure support that allows you to aim your
camera. Compose the shot, anticipating where
you'll stand. Then, start the timer and dash
into the picture and assume your pose. Most
timers will give you about 10 seconds.

Some cameras have a remote-control shutter.
Position yourself in the shot and release the
shutter with the remote control.

picture yourself...

long arms

• **Reflective surface:** Another technique is to use a mirror or other reflective material, like glass or water, to reflect your image into the camera. You will need to pre-focus your camera at the correct distance to the reflective surface and back—otherwise the photo will be out of focus.

• **Long arms:** Another technique is to hold your camera at arm's length and snap a shot of yourself. This is especially easy if you have a wide-angle lens on your camera (most lens-shutter cameras do), and long arms.

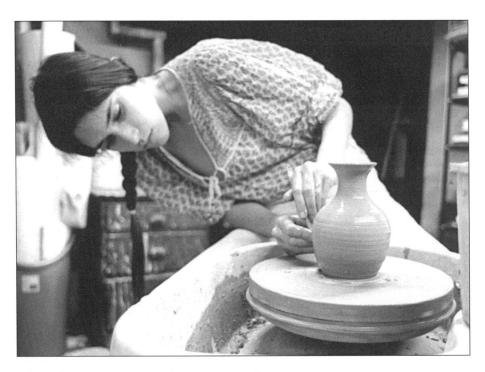

Environmental portraits

An environmental portrait is a picture of a person or several people in their everyday surroundings—where they work, play or relax. It's a photograph that shows not only the people, but the environment they live in and have created.

Use their possessions as visual props. A wide-angle lens will show more of the environment and is a good choice if you're shooting inside.

Where they work, play or relax...

Another variation on this type of portrait is to show people who are working with their hands or are completely absorbed in activity. These photos also reveal a sense of pride and interest in the subject's face. Not only are the people interesting to look at, their work is too.

Window portraits

Windows are great places to take portraits. The
light is direct but diffused and creates soft
shadows. This type of light produces flattering
portraits—an ideal assignment for a rainy day.
Have your model sit on a bench or chair close to
a large window. You can compose with the win-
dow as a background or just as a light source.

For a rainy day...

You may want to use the camera flash for fill-in light if necessary. However, the best results will be with window light because the light is diffused and natural. Shadow patterns produced by the window itself can also be especially dramatic.

Remember to keep the background simple to emphasize your subject. Think about the angle of the shot. Shooting down can create the illusion of loneliness. Shooting up can create a feeling of strength or dominance.

Also, be aware of shooting a vertical or horizontal photograph. Select the one that compliments the composition. You way want to take one of each and select the best shot later.

Tell a story.

A series of photographs, a visual essay, can be created on just about any subject, but can be an especially effective way to tell a story or capture action or an event. Weddings, birthdays and vacations lend themselves to a series of pictures. Look for images with elements that will best show what is happening—the type of place, the relationship of the people. Use close-ups along with shots from a distance to build visual variety—and show faces!

Couples

A couple photograph is one of the most common people pictures. It's a rewarding picture to take because it can show a friendship. And you'll always have two people who will ask for a print.

If the subjects are willing, consider posing them in an gentle embrace. Try to catch a moment of interaction between them.

If you're photographing buddies, a prop can add a visual element and show what they have in common.

Show a friendship...

Paparazzi
and other sneaky tactics

Some people are completely unwilling to be photographed, no matter how charming and persuasive you are. The response is frequently "Don't take my picture!" This is usually because these folks are self-conscious, concerned about their appearance or think they don't like the attention.

Paparazzi tactics are one way to overcome this problem. (Literally, a paparazzo is a news photographer who is looking for a sensational story.) This usually means catching your subject off guard with a candid shot. It can also mean that you might not be winning any friends. In fact, be ready to duck and protect your camera!

Here are several strategies:

• Sneak up and take a quick shot before the subject can pose or hide.

• Hold the camera at waist level and carefully aimed so you can shoot without looking through the viewfinder. A wide-angle lens helps if your aim is a little off.

• Aim the camera while it is still hanging around your neck. Start the self-timer and then make a face to get your subject's attention. Click goes the shutter—no hands!

• Keep a low profile, but have your camera ready. Snap an unposed candid without your subject's knowing. Don't use the flash.

• The best way to get a good shot of a shy, un-cooperative subject is to be tactful. Avoid antagonizing people. Photography should be fun for everyone, not just the photographer.

• If the sneaky photograph comes out nicely, make an extra copy for your shy subject. If they are pleased with the results, they'll cooperate next time.

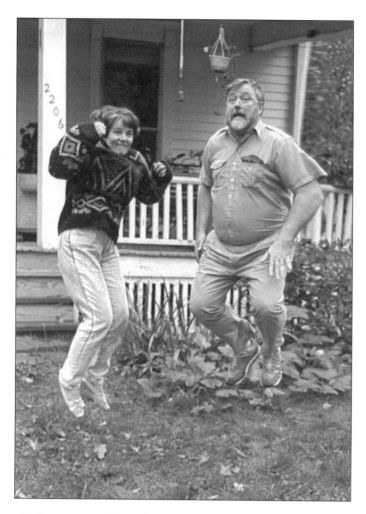

A jump shot!

One of the best ways to spice up your pictures
is to have your subjects jump in the air—a
jump shot! Jumping loosens people up and
shows them in a spontaneous, uncharacteristic
moment. Try to catch the jump at its peak
moment. Don't be afraid to ask people to jump
for your camera. It's surprising how even the
most unspontaneous and shy people will
participate.

Have fun in the air...

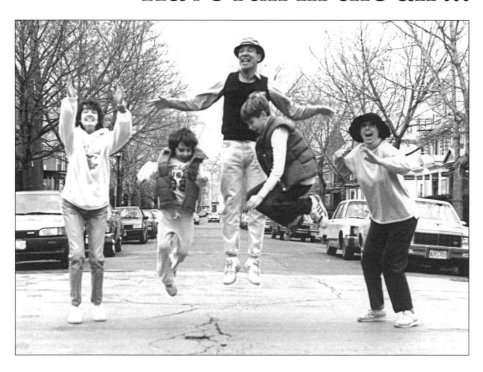

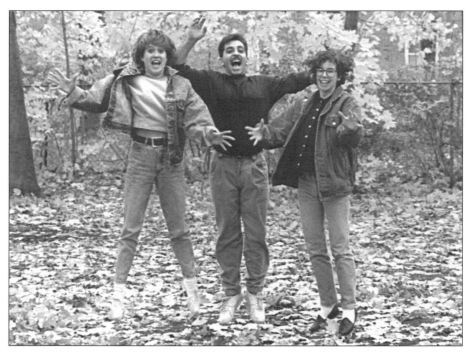

Tricks to Fantastic People Photos

✔ Be assertive.

Getting good photos requires being tactfully assertive. Move up close and ask people to pose for your camera. Don't be obnoxious or bossy. Smile, be encouraging and be confident (at least act that way). Timid photographers rarely get good photographs.

✔ Keep your subjects relaxed and at ease.

One of the obstacles to successful people pictures is self-conscious subjects. Try to take their minds off the camera. Communicate—if they're involved in conversation with you, they'll be less aware of being photographed. A prop also works well to take your subject's mind off the camera. Always thank your subjects for posing.

A checklist to success!

✔ Take extra photos.

It costs a bit more—but taking more photos increases your chances of catching more interesting moments. (Also, the extra photos make great gifts.) Avoid taking the same photo over and over. Change your composition, move closer, move farther away or look for more interesting poses, different expressions. Save and show only the best photos later.

✔ Get up close.

As a general rule of thumb, move up closer than you would normally feel comfortable doing. You'll find that your photos will have more impact.

✔ Practice.

As with anything, the more practice you have, the better you'll be. Keep your camera handy and take lots of pictures!

✔ Catch the moment.

Learn to anticipate and catch the peak moment of expression. These are the photos that will be the most exciting and the most memorable.

✔ Be creative and have fun.

Experiment. Try new things with your picture-taking. You'll always find new ways to make your photos more interesting.

✔ Show off your photos!

Your photographs are fun and enrich your life—so show them off and make them part of your environment. Photos also make an excellent gift to friends and family.

Chapter 14

Index

Need more copies?

--

For new Single-lens-reflex owners...

--